MULAS / CALDER

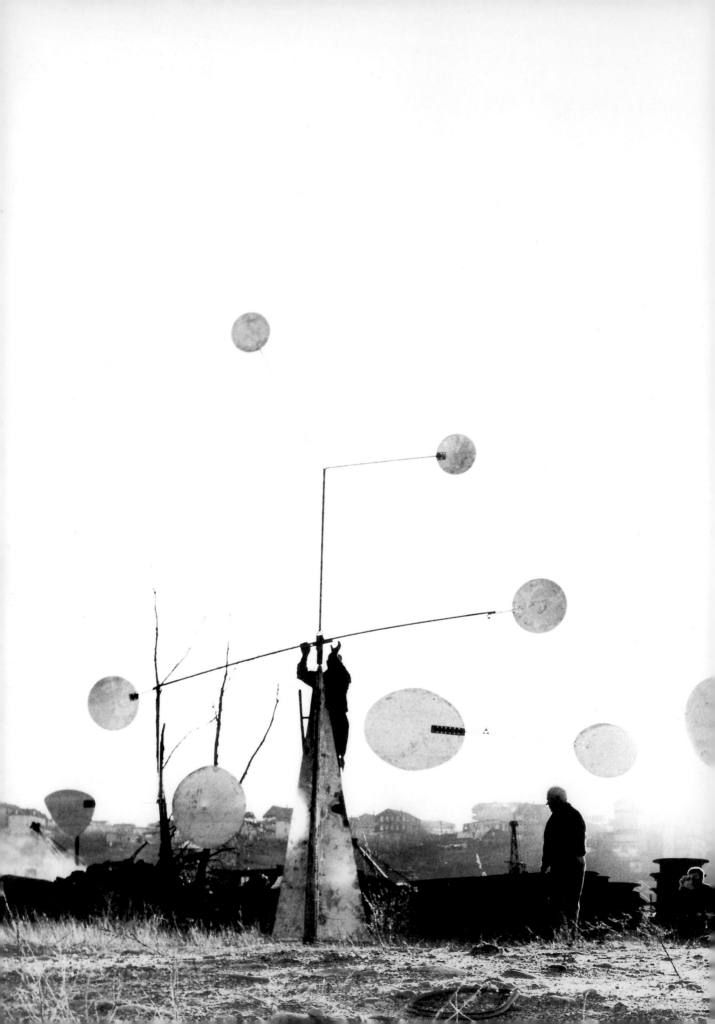

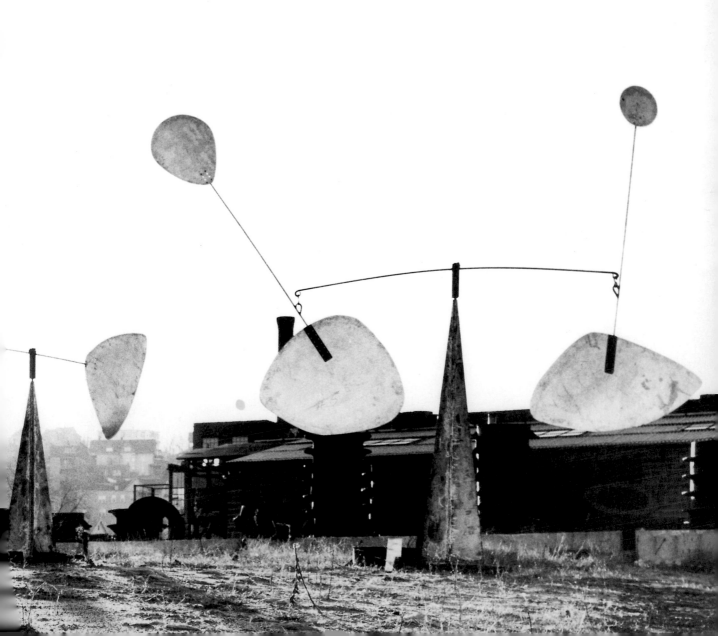

COVER
Thirty-Two Discs / La Douche, 1951
Saché, 1967

The publisher thanks Paola Argan for her kind permission
to use the text by Giulio Carlo Argan, Melina and Valentina
Mulas for permission to reproduce the photographs, and
the Calder Foundation and the Archivio Ugo Mulas for their
contributions to compiling the biography and captions.

Translation from Italian
Timothy Stroud

Graphic design
Paola Gallerani

Colour Separation by
Trifolio, Verona

Printed and bound by
Trifolio, Verona

This book is set in Berthold Akzidenz Grotesk.
Printed on Satimat naturel Arjowiggins in June 2008
ex Officina Libraria Jellinek et Gallerani

ISBN 978-88-89854-21-1
Printed in Italy

UGO MULAS / ALEXANDER CALDER

Introduction by Giulio Carlo Argan

OFFICINA
LIBRARIA

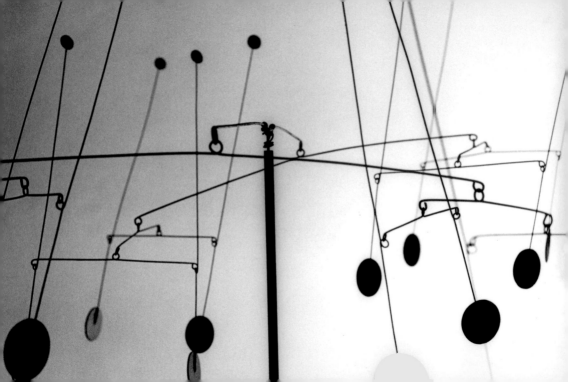

CONTENTS

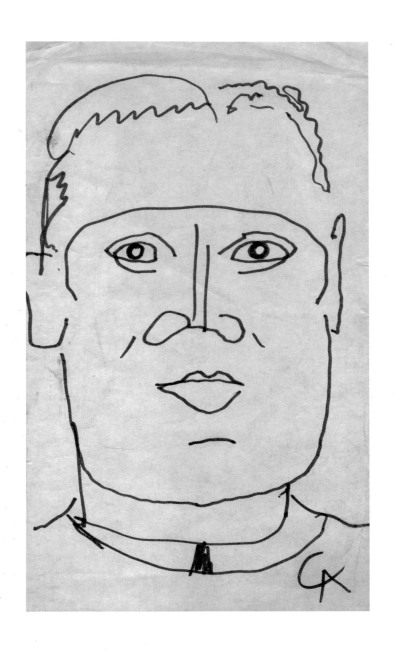

Art criticism verbalises works of art, which are conceived as images. They locate artworks within the overall system of a culture whose structure is formed of discourse and whose interdisciplinary cohesion is provided by language. In this transposition, a work of art is revealed as a cultural component but loses its specificity, it ceases to be an image and becomes discourse.

In the sphere of the imagination, images form associations and resist one another in accordance with dynamics that are very different to the logic of discourse: they form relationships whose complexity constitutes the development of art as a discipline unto itself. In substance, the iconological method in art history aims at reconstructing the paths followed by an image in the dimension of the unconscious, the dimension in which the image stimulates an active response rather than loses itself in conceptuality. It is at this moment that art generates art and images proliferate, combine, even influence one another, expanding the dimension of imagery unrestrictedly, without crossing the threshold of discourse.

Today the generating principle of imagery is photography.

The process of re-production and transformation of the artistic image takes place in what is still a fairly mysterious domain (the lens, the dark room) when compared with the previous method, that of engraving, which used very different procedures and had very different aims. Photography removes the insubstantial film from the image of the singularity and material nature of the artistic object, and the freed image, when multiplied and made more visually intense, begins a completely different existence.

More than anyone else, the great photographer Ugo Mulas studied the structures of photographic semiotics and their relationship with artistic representation, of which the photograph is the continuation in a mass culture that excludes the fixation of the image and its reduction to an object.

He chose Calder's work as his area of research, not because Calder was a nice guy, though Calder was liked by everyone, but because it allowed him to check very clearly, point by point, the passage from image structures of manual artistic techniques to those of advanced industrial technologies. In short, Mulas's series of photographs of Calder should be thought of as an extremely penetrating and persuasive work of non-verbalised art criticism.

There were several reasons for Mulas's choice.

First, Calder made moving sculptures in which the image was not linked with an object, on the contrary, the object was a perpetual generator of images, and this left a large degree of freedom to chance, the precariousness of balances, and the possibilities offered by the environment.

Second, Calder used manual crafts' techniques, ostentatiously humble and simple, but he was an engineer turned mechanic as a form of protest, and from mechanic to artist from choice. He did not challenge the system but his candour was slightly mocking.

Third, in its apparent and vulnerable simplicity, the morphology of his works was ambiguous and amphibious: half mechanical and half natural.

Fourth, in returning to manual techniques he rediscovered nature, and succeeded in creating things that immediately made themselves at home in their surroundings: they took pleasure in the light and air, and rustled and shook like leaves in the wind.

And fifth, there was a similarity a physical, persistent link, that only photography could capture between the artist and his creations, which demonstrated the banality of the interpretation then current of how much Calder was simply an adult who had never grown up and his sculptures were his toys.

A subtle analyst of photographic structures, Mulas did not allow himself to be beguiled by colour, and worked in black and white. He knew that in photography colour is a superstructure, and that colour photographs are in fact just black-and-white pictures overlaid with colour. But in monochrome Mulas was a genius: he succeeded in freeing ranges of such purity that, in comparison, colour represented nothing but daubs.

For the same reason he forbore from capturing the movement of the mobiles with a movie camera, and I am truly thankful that his intelligence prevented him from indulging in the specious genre of a film on art. Furthermore, he was aware that reportage is not an application but is part of photography's intrinsic functionality: thus, while he allowed the slow rhythms of the artist's manual techniques to transpire, he also dissolved them in the fluid, digressive sequences of reportage.

Naturally, a sequence of this nature focused on the development of a mobile as well as incorporating several other dimensions: it not only revealed the close relationship between the artist and his work, the ingeniousness of his astute handiwork, and the sophistication of his wit, but it also enabled the inclusion of his wife, his house and studio, a tour of the plants in the garden, a long shot of the landscape and even a view through those moving elements of nature, the clouds. Detached from solid objects, the images moved freely around the interior and exterior settings. It was with this careful structuring of the congenial surroundings that Mulas's photographic criticism filled the gaps in his formal criticism, which was unable to give an absolute value to the works of art without suppressing its relations with the physical reality of the artist and the environment.

Mulas caught with incredible delicacy the genetic affinity between the works and their creator, and at the same time their intimate contradiction, as if the lightness of the sculptures atoned for the sculptor's heavy bulk and their capriciousness matched his kind-hearted, unpredictable character, the nature of which is expressed by the tufts of his white hair, ever tousled by a non-existent wind.

Calder looking at himself in the white page of a silkscreen print like an old Narcissus in the spring, and smiling at his own image; Calder drinking, sleeping, laughing and playing with his sculptures like a child with a kite; Calder in his workshop, packed, like a halo, around his handyman figure; Calder with his tools, making pieces for his sculptures with his intelligent, agile hands the hands of a pianist or a thief.

Or his contest with the landscape, in which he set out gigantic, pointed sheets of metal like dinosaurs, or his studio glassed like a greenhouse, in which his sheet-metal sculptures appeared like tropical plants.

With his lens Mulas understood intuitively what art criticism had not said: before, sculpture consisted in giving matter to an image, but Calder took matter and transformed it into an

image as light as a puff of air. Like Dosso Dossi's Jupiter, he was a maker of large and multicoloured butterflies.

Mulas's carefully controlled compilation of photos of Calder has its own critical raison d'être. Calder did not work in isolation: his relationship with Arp and Miró was evident though not analogical. Deeper analysis shows that the seeds of the morphology of his work could not avoid certain important similarities with Gorky and Kline.

It was a morphology that certainly eluded the Cartesian coordinates on which the European space was built, seemingly derived from the movement of the leaves or the unpredictable flight of birds and insects. But, unlike the others, to evade the nightmare of alienation, Calder did not create myths, just delicate instruments able to mediate an artificial but nevertheless gratifying relationship between individuals and environment.

Nor did it escape Mulas that underlying Calder's works was a love of geometry.

He gave a very clear, articulated, metric and very European interpretation of this American artist fed up with American mechanical productivity. And without the usual, annoying high spirits of the playful Calder happy to live in the best of all possible worlds.

Mulas's account contained points that no verbalised critical study could bring out, that only an image-based approach on the subject of images is capable of discovering.

Calder's imagination was no more successful in removing the tragic quotidianity from the world any more than Mondrian's rationality.

On this the photographic reportage of Ugo Mulas leaves no shadow of a doubt.

Giulio Carlo Argan
Rome, March 1982

This essay was first published as the introduction to: Ugo Mulas. *Alexander Calder in Saché and Roxbury 1961–1965*, exhibition catalogue (Rimini, Galleria dell'Immagine, Palazzo Gambalunga, 24 April–29 May 1982), Rimini 1982.

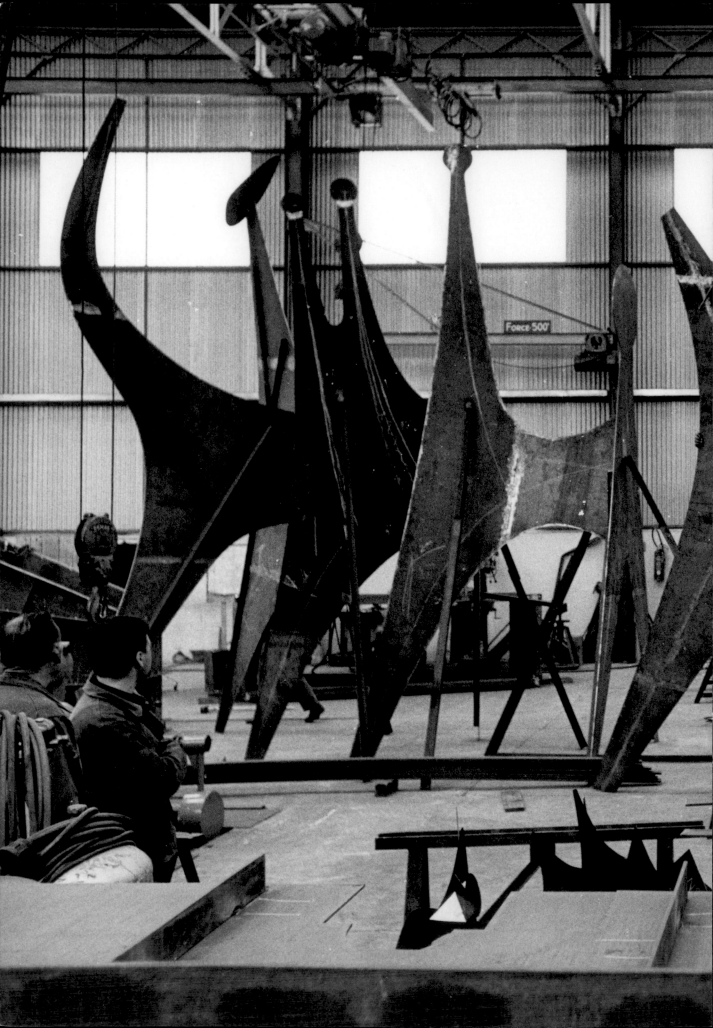

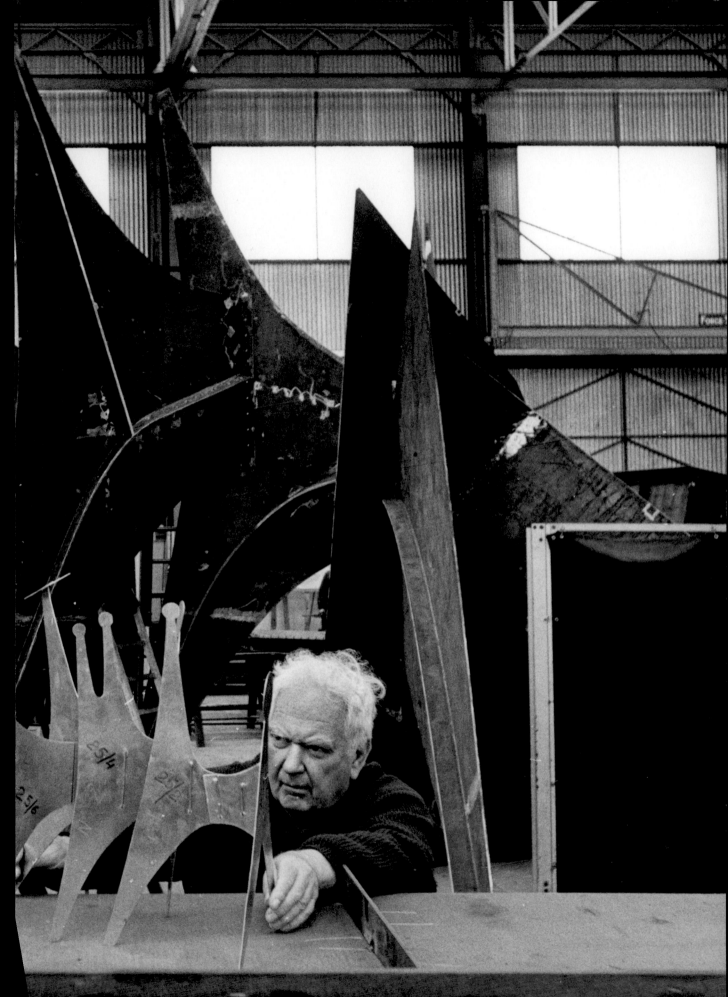

Ugo Mulas is born on 28 August 1928 in Pozzolengo, near Desenzano del Garda in Lombardy. After completing his schooling in Desenzano, he begins to study Law in Milan but leaves to follow arts courses at the Accademia di Brera. He becomes a habitué at the Giamaica Bar in Via Brera, a hangout for artists and intellectuals, and becomes interested in photography. His first professional assignment as a photographer is in 1954 when he is asked to cover the Venice Biennial with the photojournalist Mario Dondero, also a friend. During his period, he photographs the suburbs of Milan and the waiting room at Milan train station.

To earn a living he does advertising and fashion photography, plus assignments for magazines and newspapers, but his main interest is the art world. He records every Venice Biennial up until 1972, photographing the most salient moments, such as Alberto Giacometti's protest at the awards ceremony in 1962 and the success of American artists in 1964.

He begins working with Giorgio Strehler, the director of the Piccolo Teatro in Milan. In 1960 he travels around Europe creating a report with Giorgio Zampa for *L'Illustrazione italiana*, and other magazines such as *Settimo giorno*, *Novità*, *Domus* and *Du*. He also works for the advertising departments of Pirelli and Olivetti.

In 1962 he photographs the Spoleto Festival and David Smith in his studio in Voltri. His friendship with Alexander Calder begins in Spoleto and this same year he photographs the artist in Saché (France) and in 1964 in Roxbury (Connecticut).

In 1964 he also takes photographs to illustrate the poems of Eugenio Montale, in particular *Ossi di Seppia*. At the Venice Biennial he meets the New York art dealer Leo Castelli and many American Pop artists, and decides to leave for New York immediately. This first trip is followed by others in 1965 and 1967, during which time he puts together an extraordinary body of photographs that document the New York art world.

His collaboration with Giorgio Strehler leads him to develop a new mode of stage photography inspired by Brecht's notion of alienation, an example of which is the direction of *La Vita di Galileo* in 1964.

In 1969 he works with the director Virginio Puecher on two important theatre productions. He photographs the productions of Benjamin Britten's *The Turn of the Screw* at the Piccola Scala in Milan, and Alban Berg's *Wozzeck* at the Teatro Comunale in Bologna.

In 1970 he falls seriously ill but begins his last series of photographs (*Le Verifiche*).

He dies on 2 March 1973 in Milan.

ALEXANDER CALDER BIOGRAPHY

Alexander Calder is born in Lawnton, Pennsylvania, in 1898, the second child of artist parents. During his childhood he is encouraged to create, but Calder doesn't set out to become an artist.

He graduates from the Stevens Institute of Technology in 1919 with an engineering degree and works at various jobs for several years.

In 1923 he moves to New York and enrols at the Art Students League. He takes a job illustrating for the *National Police Gazette*, which sends him to the Ringling Brothers and Barnum & Bailey Circus to sketch circus scenes in 1925.

After moving to Paris in 1926, he creates his *Cirque Calder*: the assemblage included diminutive performers, animals, and props. Fashioned from wire, leather, cloth, and other found materials, *Cirque Calder* is designed to be manipulated manually by the artist.

Calder finds he enjoys working with wire: he begins to sculpt from this material portraits of friends and public figures of the day.

In 1928 Calder has his first solo gallery show at the Weyhe Gallery in New York.

In October 1930, Calder visits Mondrian's studio in Paris and is deeply impressed by a wall of coloured paper rectangles that Mondrian continually repositioned for compositional experiments. This experience "shocks" him toward total abstraction.

In January 1931 he marries Louisa James (a grandniece of Henry James). He also becomes friendly with many prominent artists and intellectuals, including Joan Miró, Fernand Léger, James Johnson Sweeney and Marcel Duchamp. In the fall of 1931, he creates his first truly kinetic sculpture and gives form to an entirely new type of art. The first of these objects moved by systems of cranks and motors, and are dubbed "mobiles" by Duchamp. Calder soon abandons the mechanical aspects of these works when he realizes he could fashion mobiles that would undulate on their own with the air's currents. Jean Arp, in order to differentiate Calder's non-kinetic works from his kinetic works, names Calder's stationary objects "stabiles."

In 1933, Calder and Louisa leave France and move to Roxbury (Connecticut). Their first daughter, Sandra, is born in 1935, and Mary follows in 1939. Calder's earliest attempts at large, outdoor sculptures are also constructed in this decade. In 1937, Calder creates his first large bolted stabile fashioned entirely from sheet metal, which he entitles *Devil Fish*.

Because metal is in short supply during the war years, Calder turns increasingly to wood as a sculptural medium. Working in wood results in yet another original form of sculpture, works called "constellations" by Sweeney and Duchamp.

The 40s and 50s are a remarkably productive period for Calder. A major retrospective is held at the Museum of Modern Art in New York in 1943.

In 1945, Calder makes a series of small-scale works which intrigue Duchamp during a visit to the studio. Inspired by the idea that the works could be easily dismantled, mailed to Europe, and re-assembled for an exhibition, he plans a Calder show at Galerie Louis Carré in Paris, held the following year. Jean-Paul Sartre writes his famous essay on Calder's mobiles for the catalogue.

Calder concentrates his efforts primarily on large-scale commissioned works in his later years, including *La Spirale*, for UNESCO, in Paris (1958); *Man*, for the Expo in Montreal (1967); *El Sol Rojo* for the Olympic Games in Mexico City; *La grande vitesse*, the first public art work funded by the National Endowment for the Arts, for the city of Grand Rapids, Michigan (1969).

Calder's artistic talents are renowned worldwide by the 1960s. Retrospectives are held at the Guggenheim Museum in New York (1964), at the Fondation Maeght, in Saint-Paul-de-Vence (1969) and finally at the Whitney Museum of American Art in New York (1976). Just a few weeks later, Calder dies at the age of 78.

LIST OF THE PLATES

Ugo Mulas has shot hundred of photographs of Alexander Calder and his sculptures. The photographs chosen for this book emphasise the photographer's focus on backgrounds – an element that radically alters our perception of the work of art itself – to the extent of 'colouring', through darkroom development, the portrait of Kiki de Montparnasse (p. 33), or altering their three-dimensional impact, as in the case of the acrobats, or the mobiles, a balancing act between sculpture and drawing.

This reflection on perception is also central to the photographs of the monumental sculptures: the framing purposely makes it difficult to distinguish between the sculptures and their small-scale models.

The captions give the name of Calder's works and their dates of execution; the year and the place where the photograph was taken are also given.

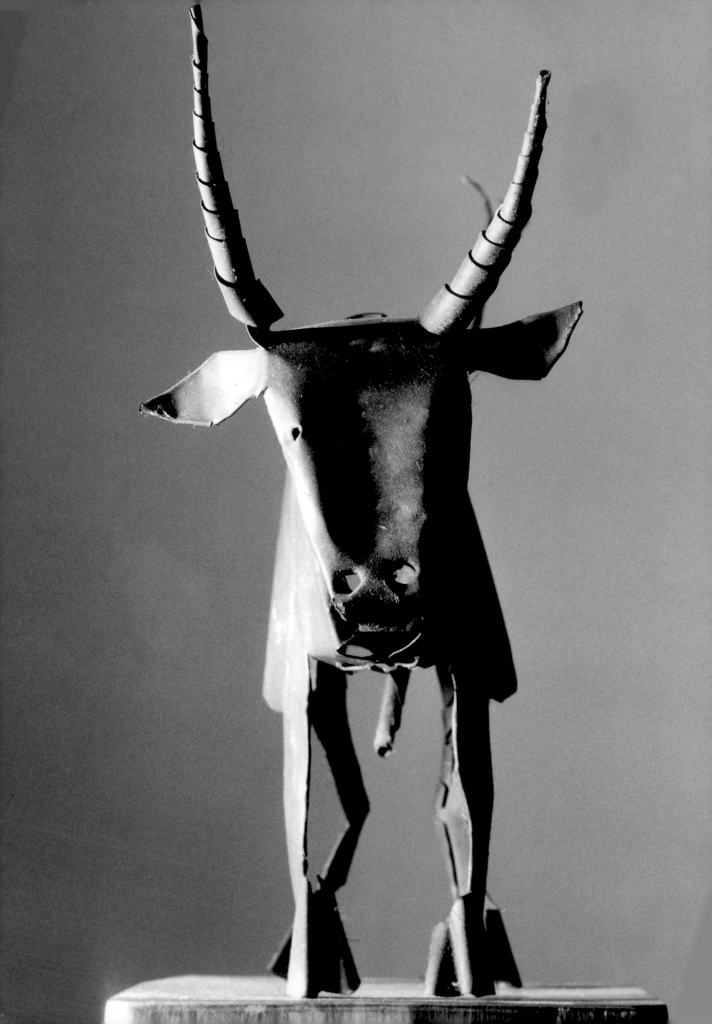

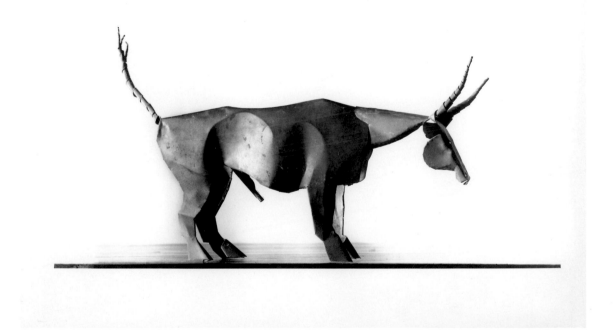

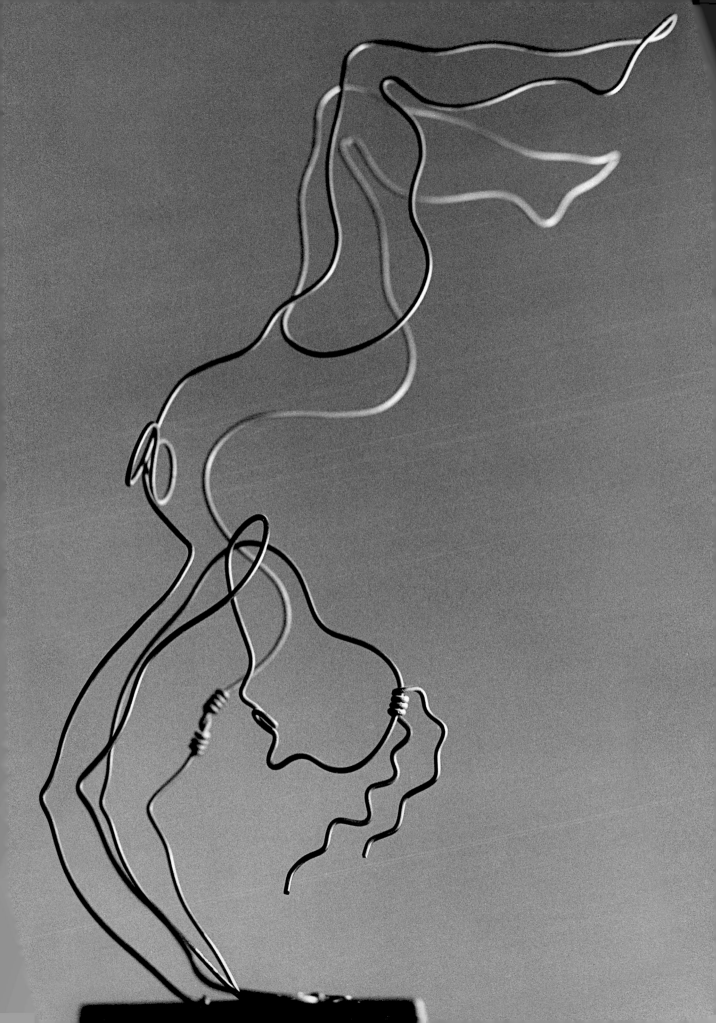

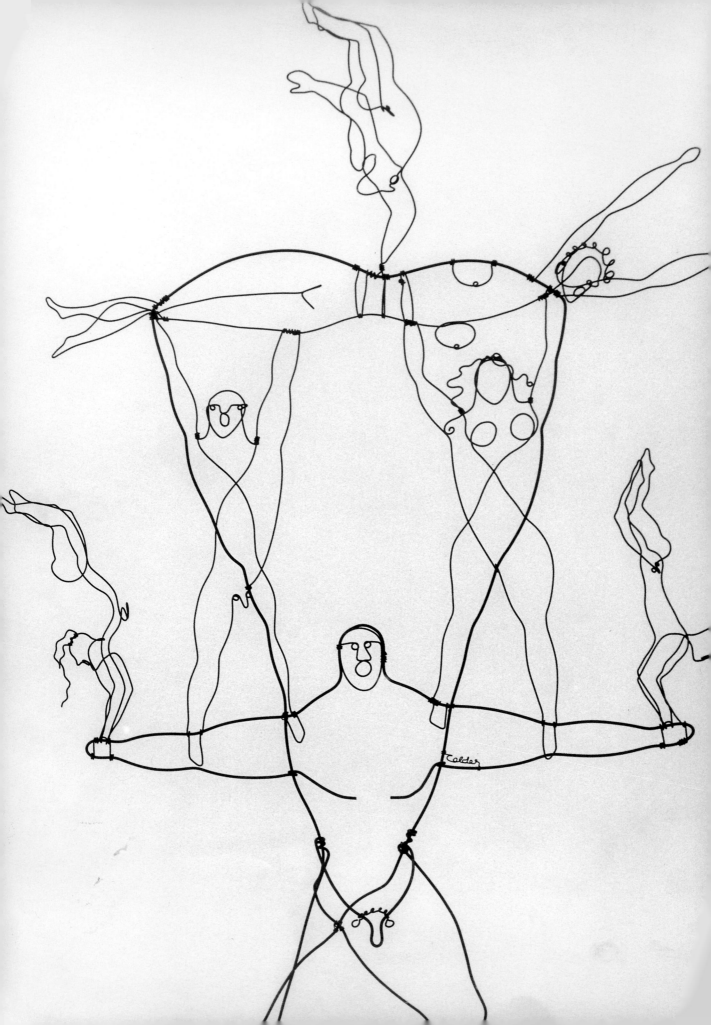

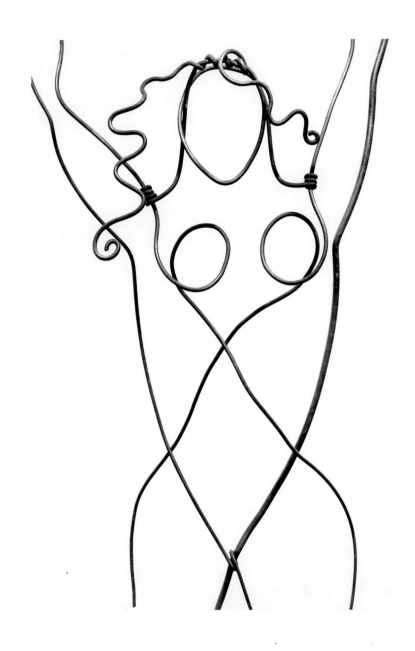

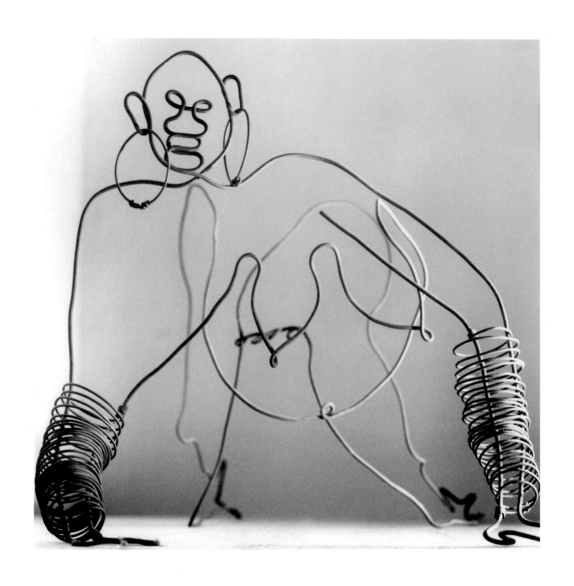

24

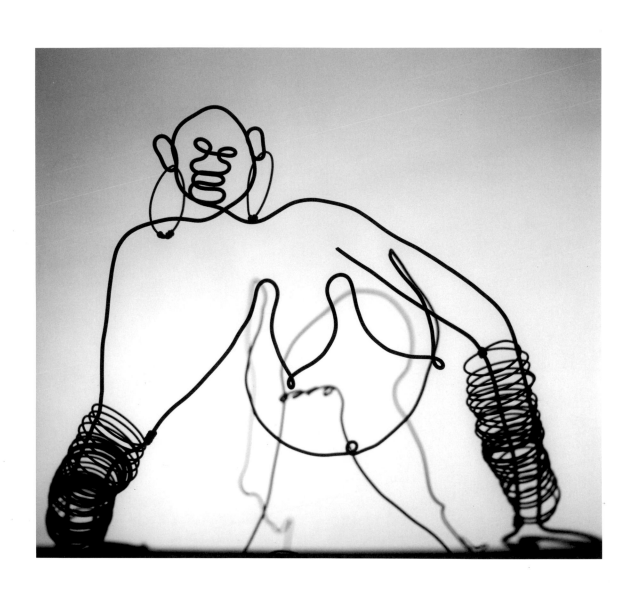

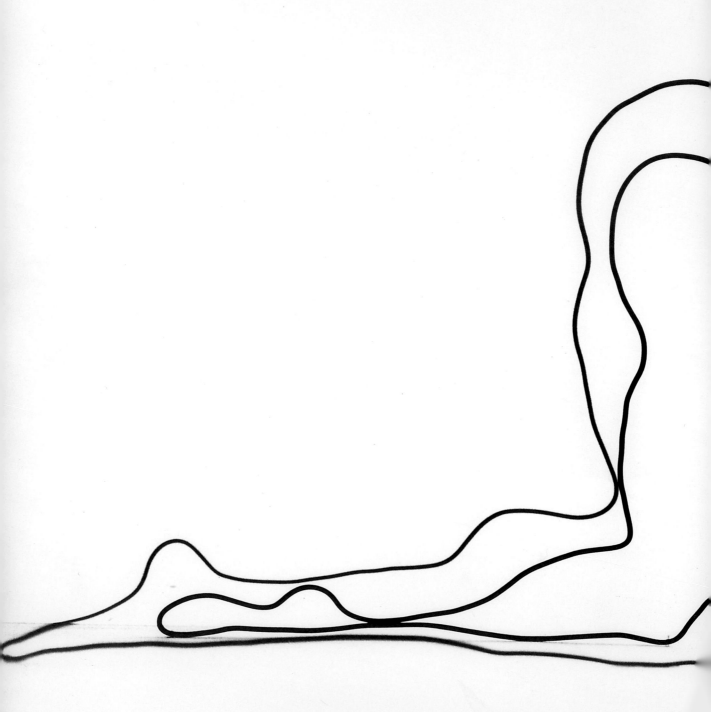

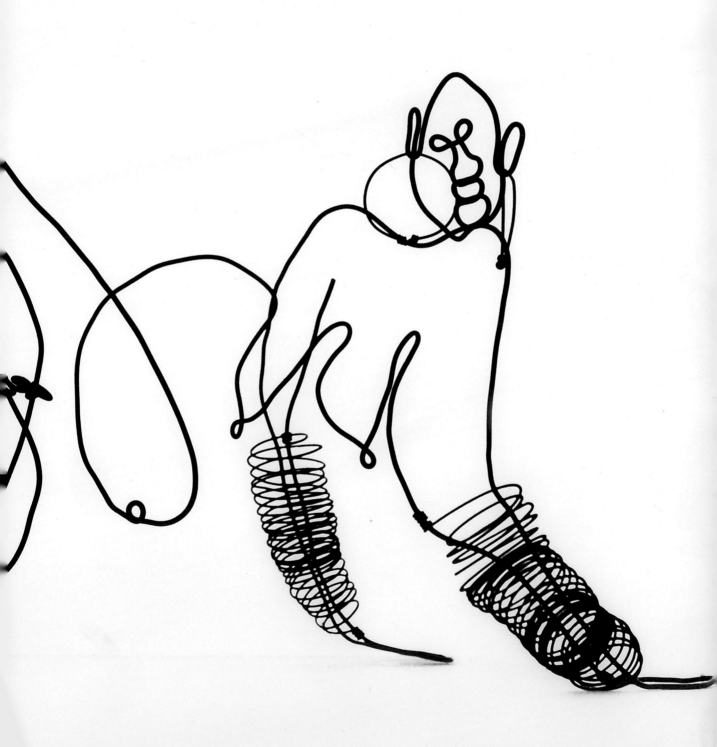

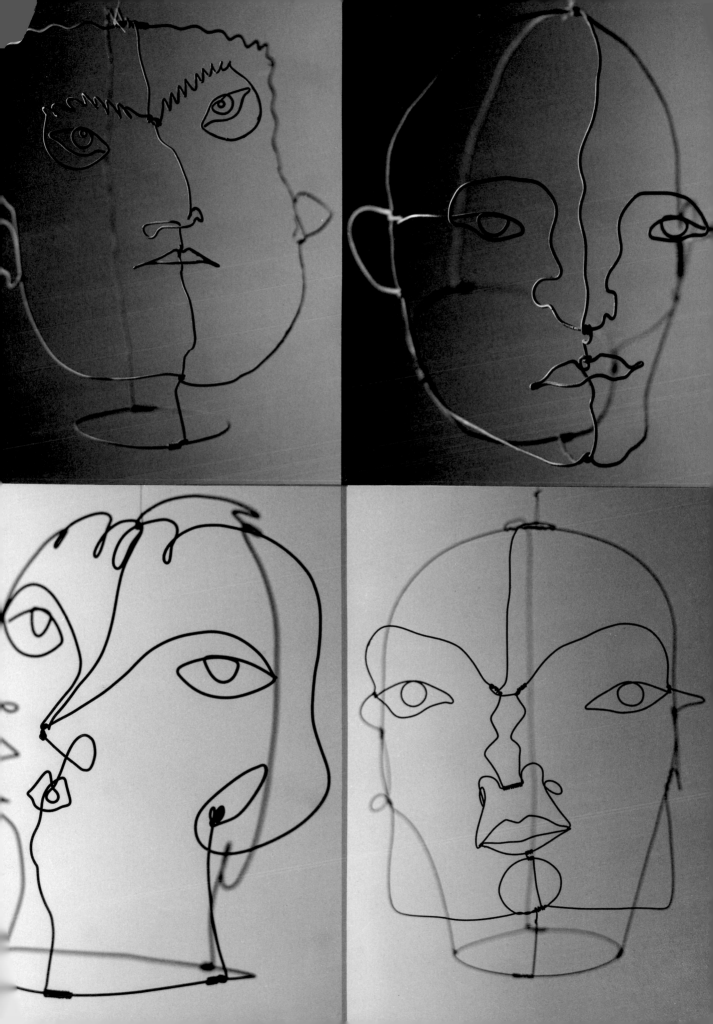

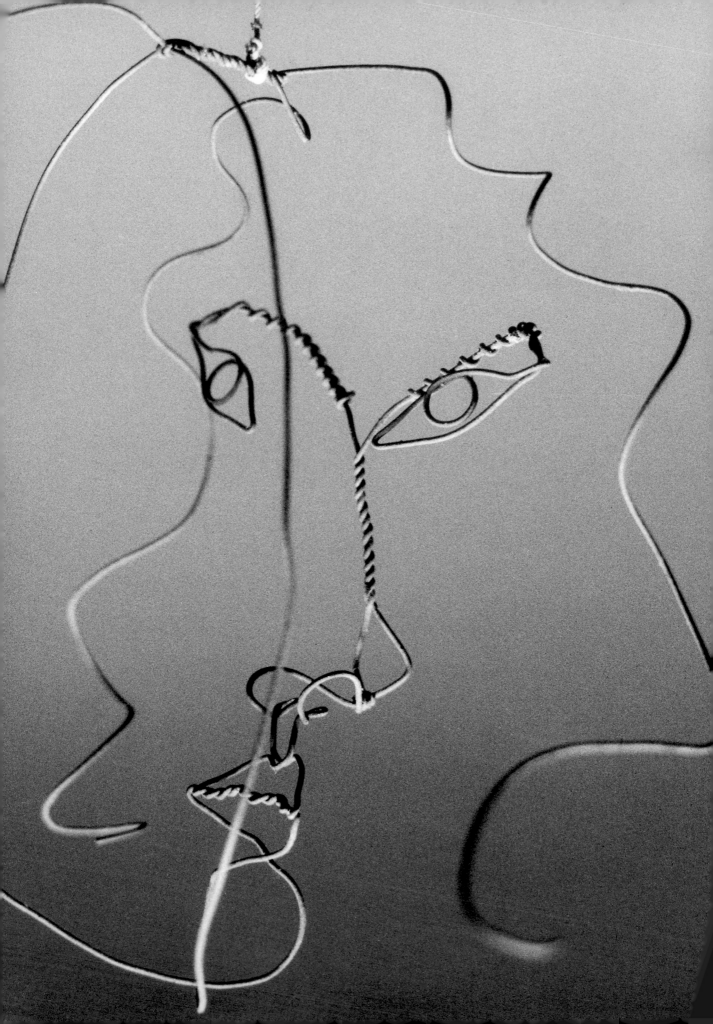

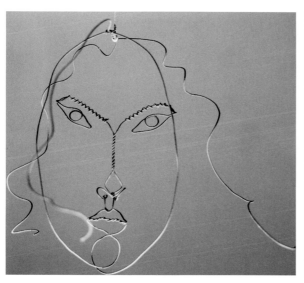 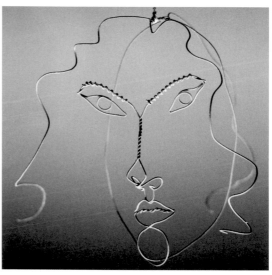

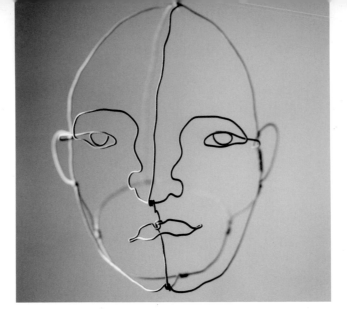

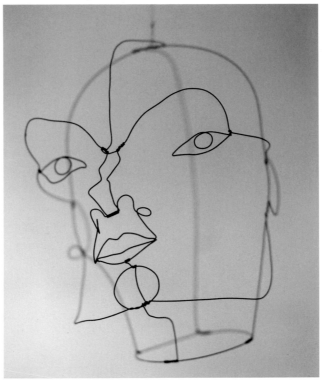

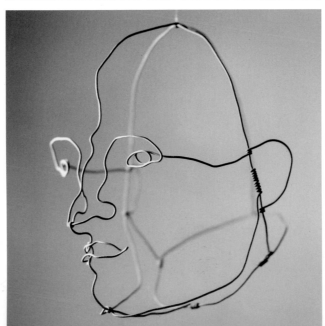

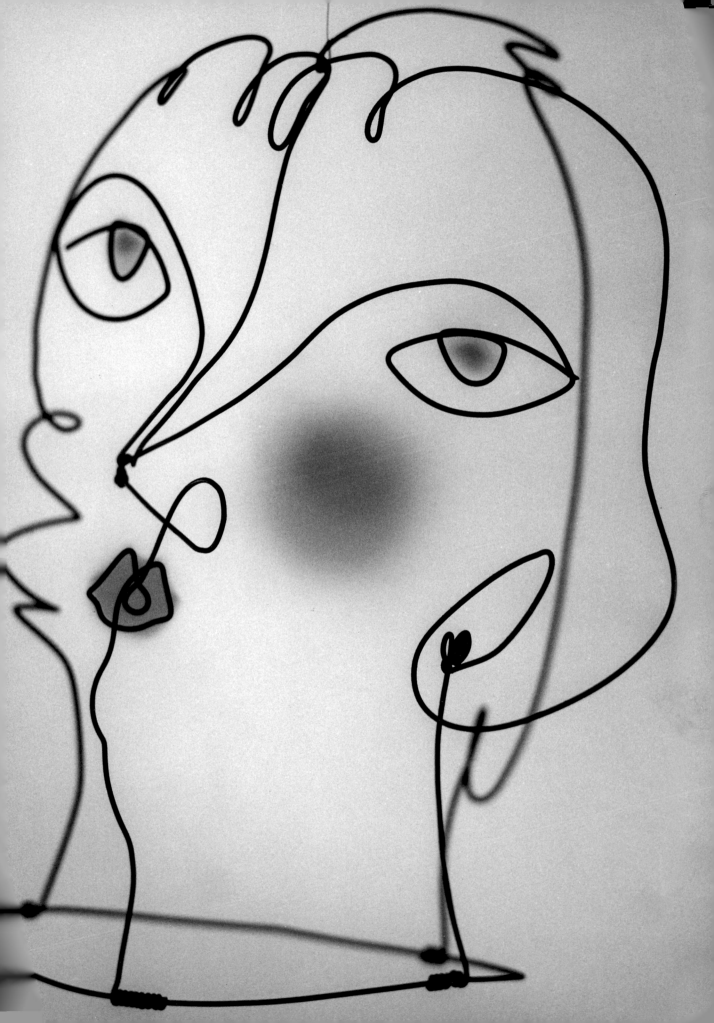

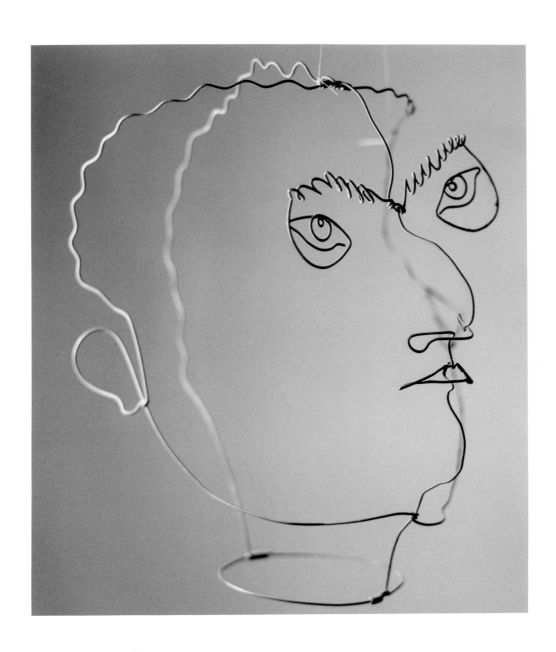

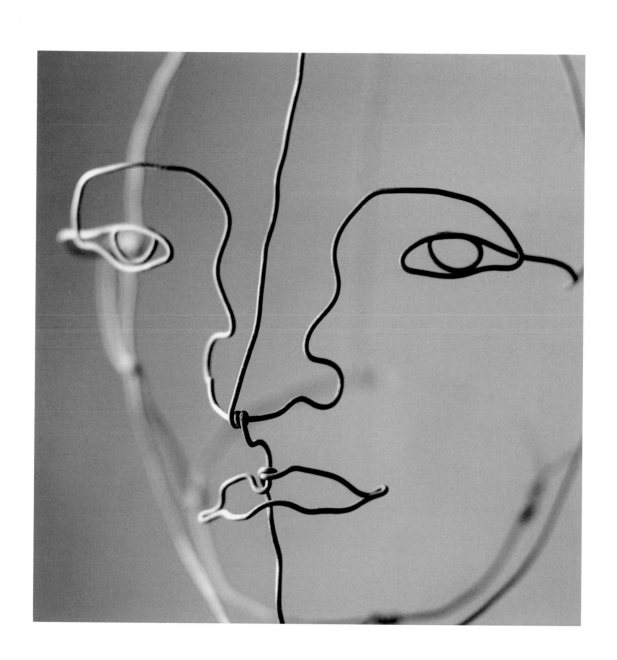

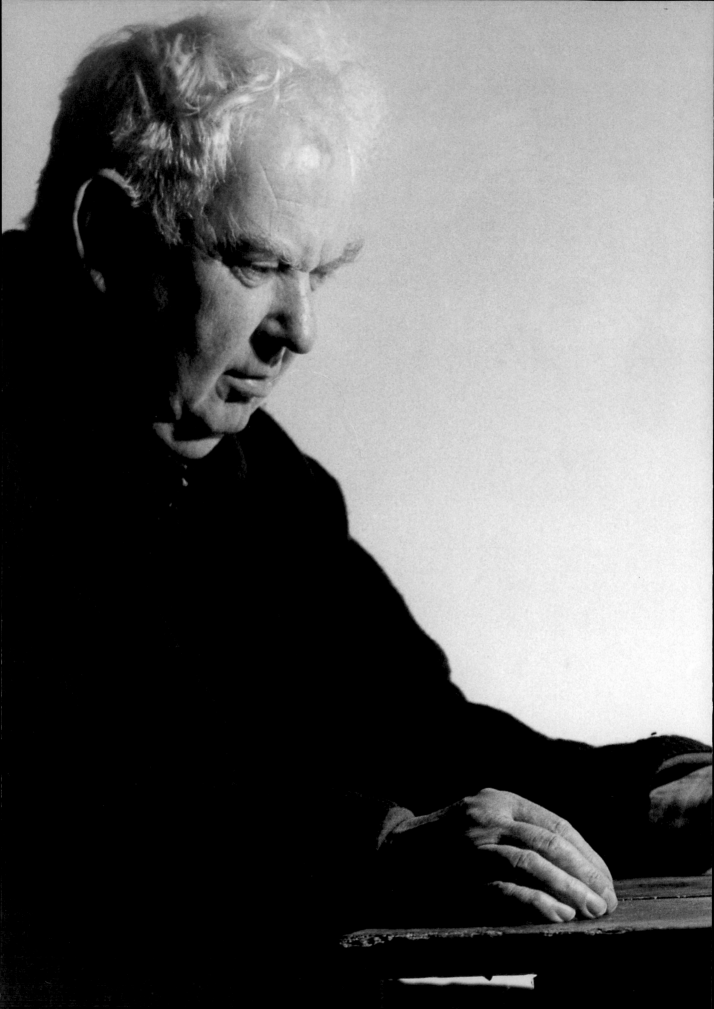

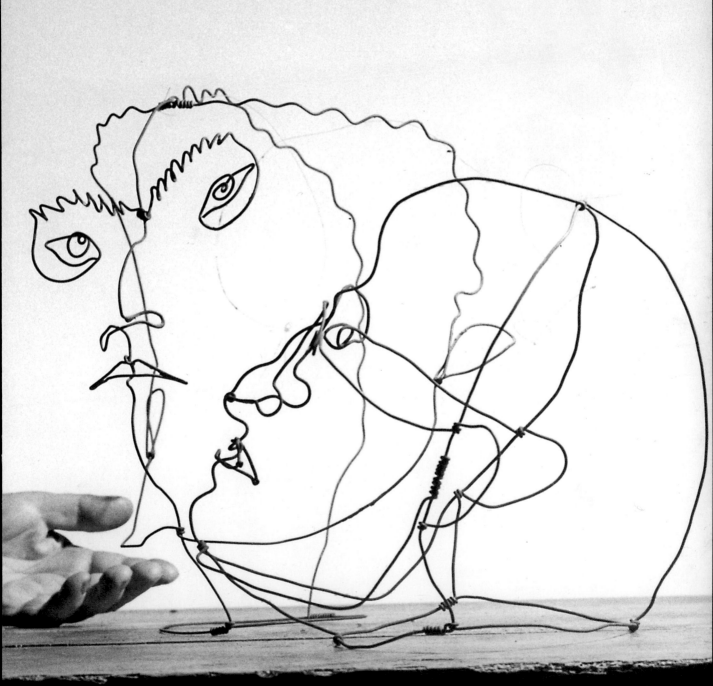

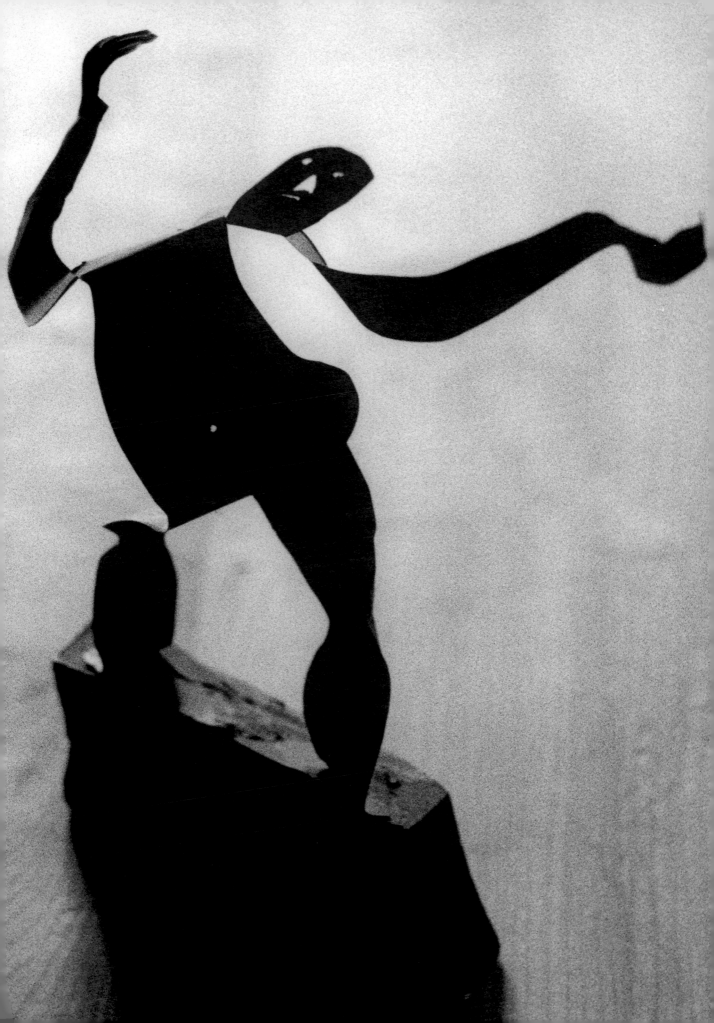

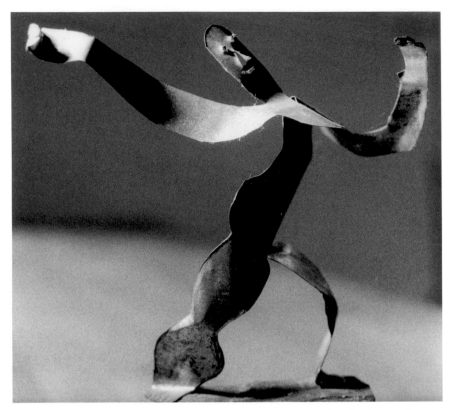

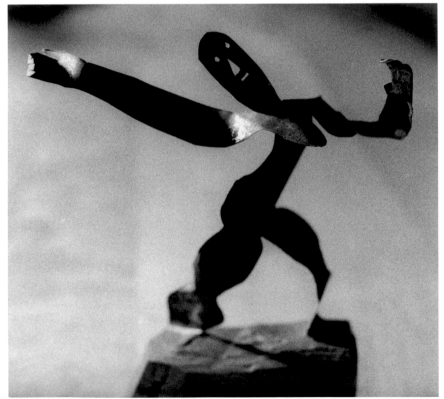

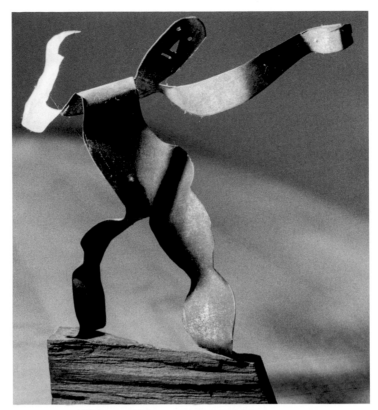

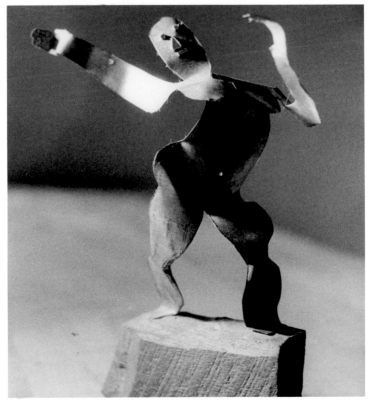

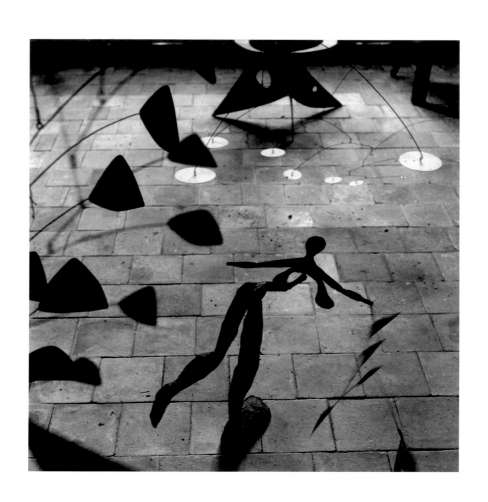

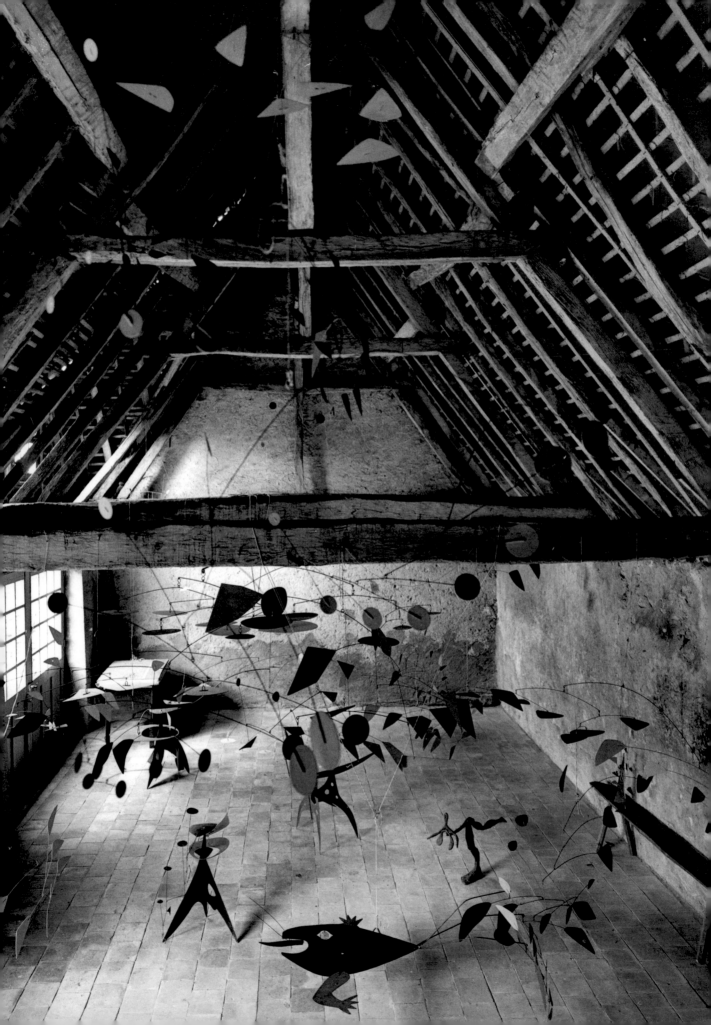

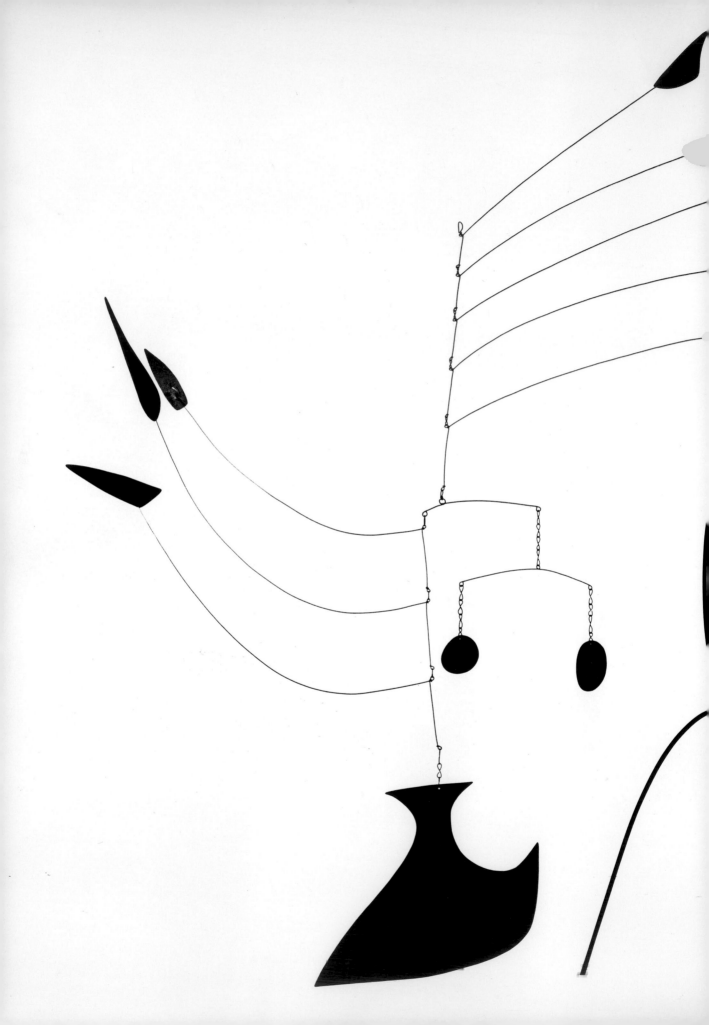

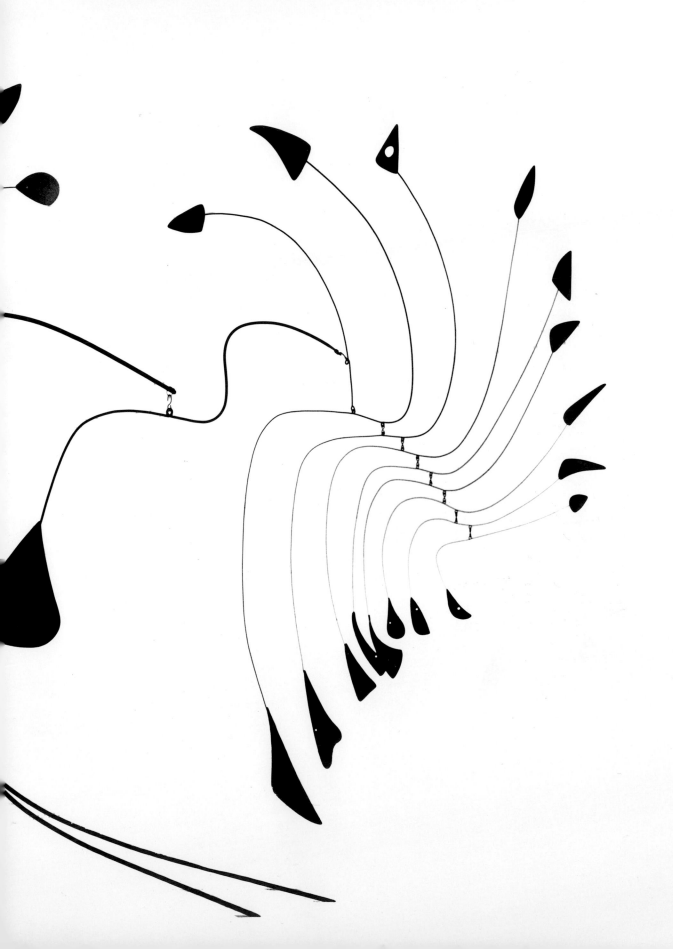

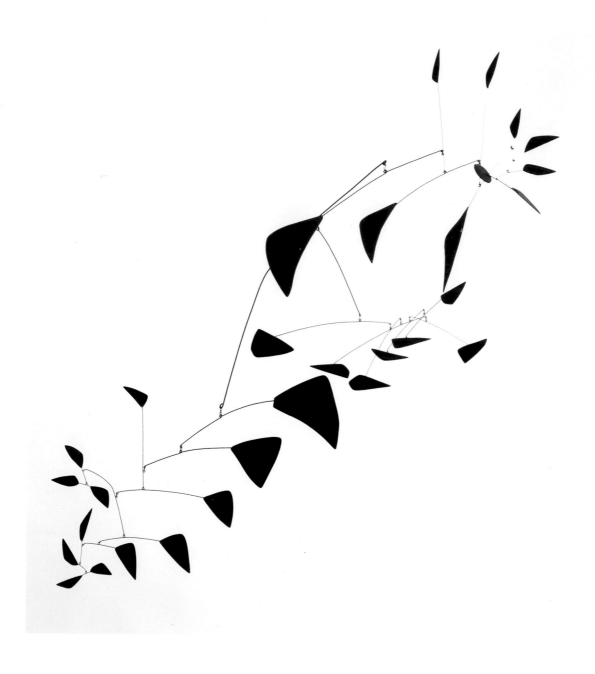

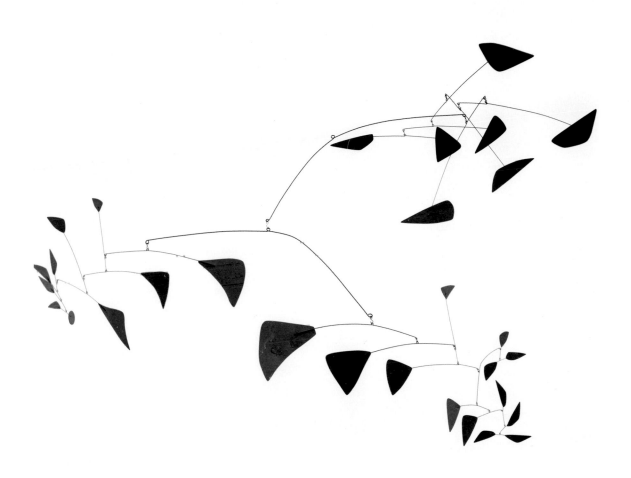

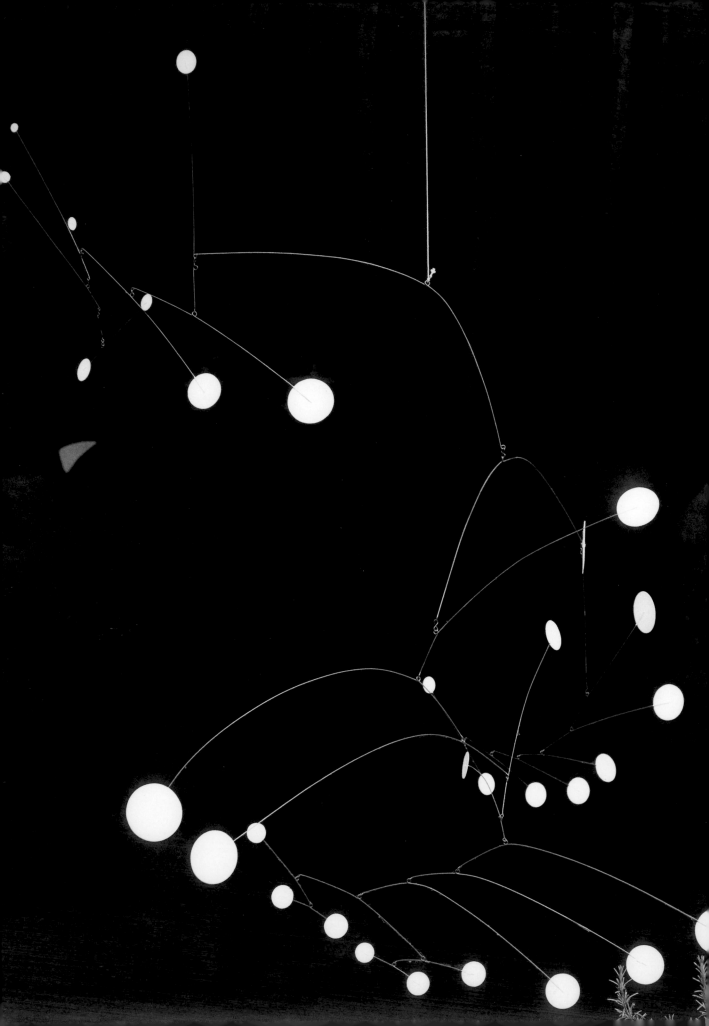

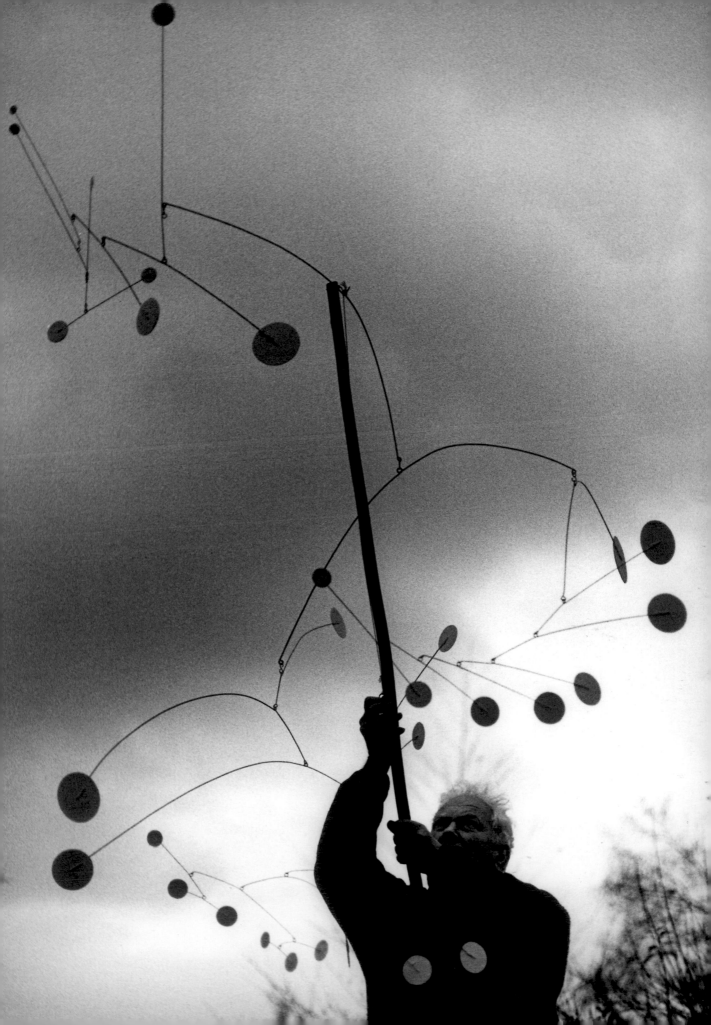

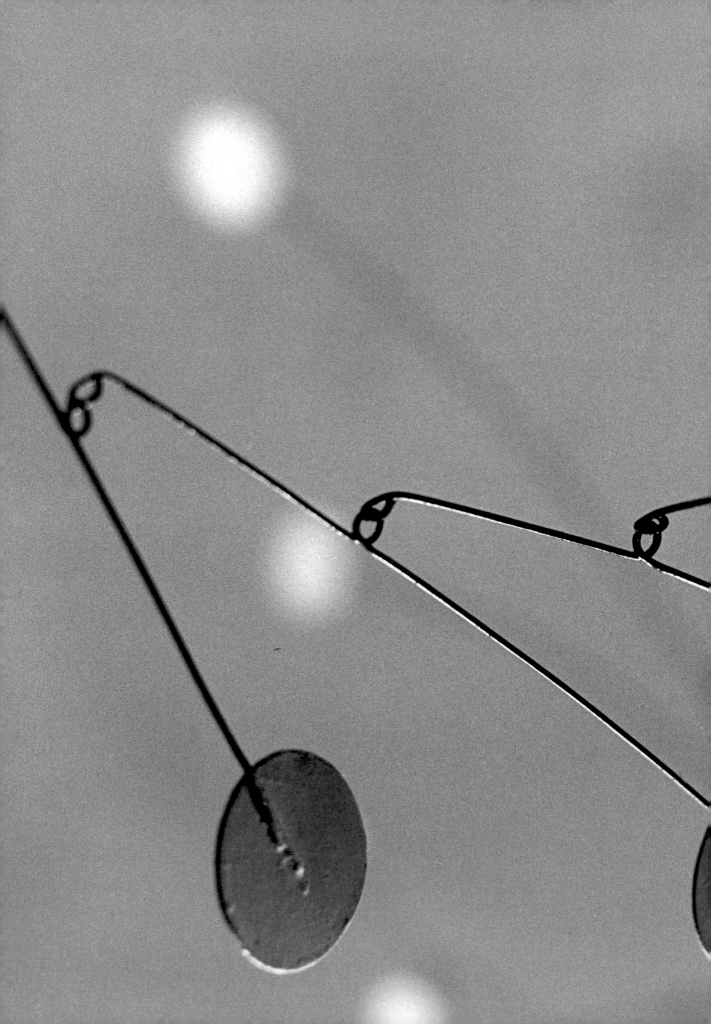

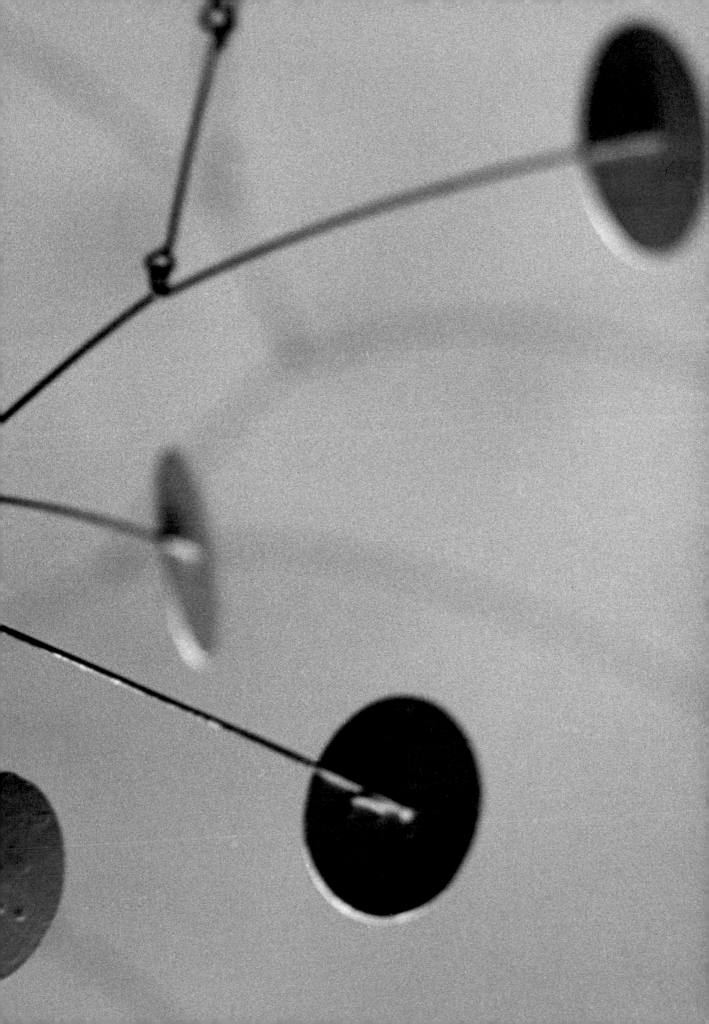

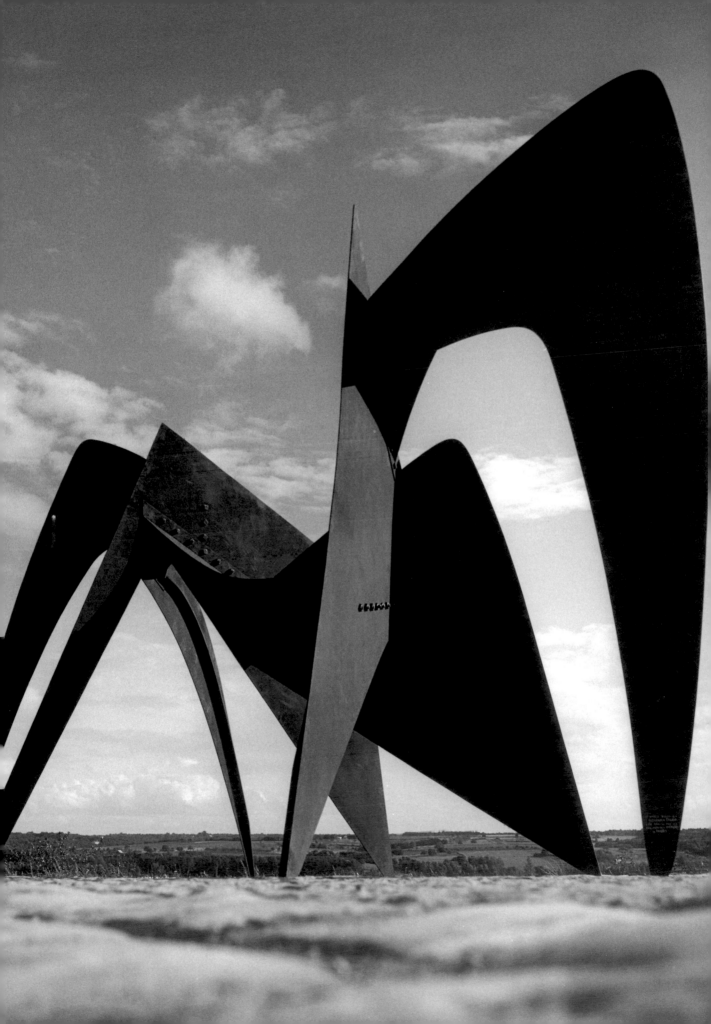

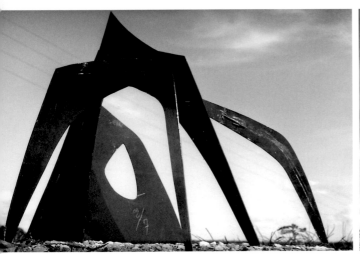 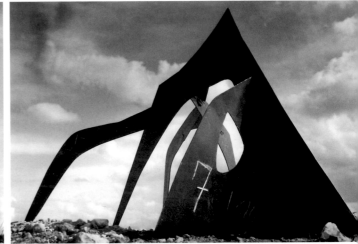

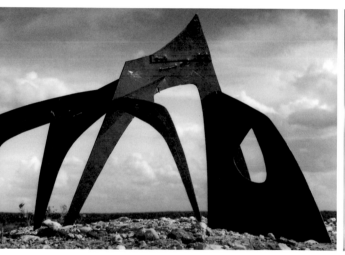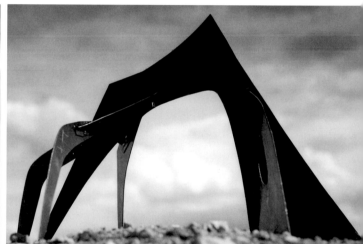

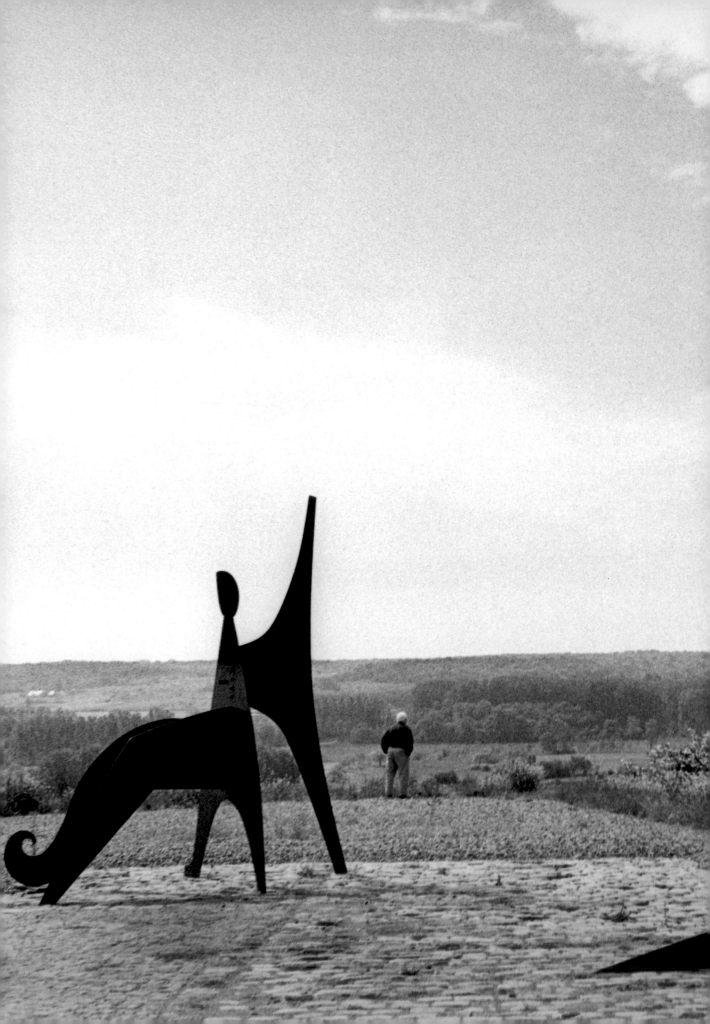

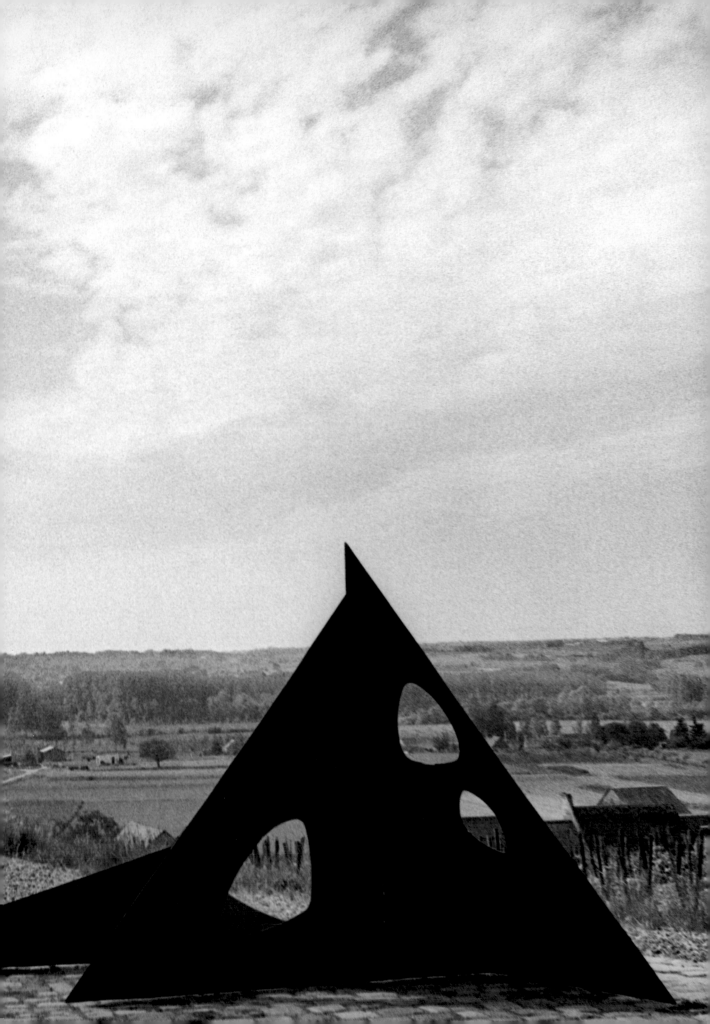

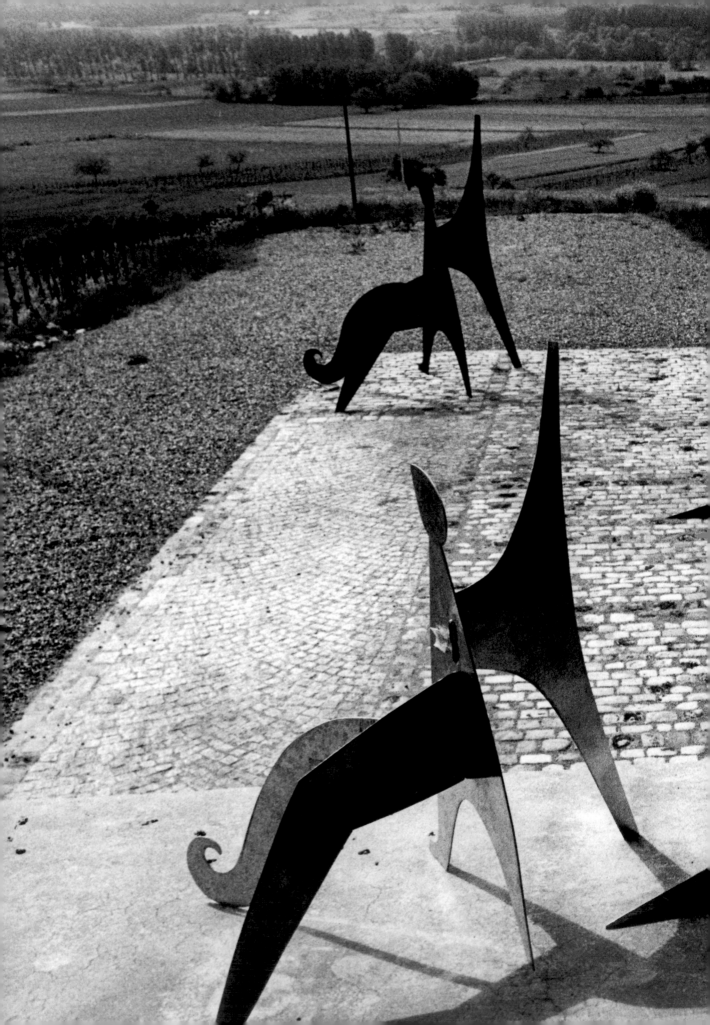

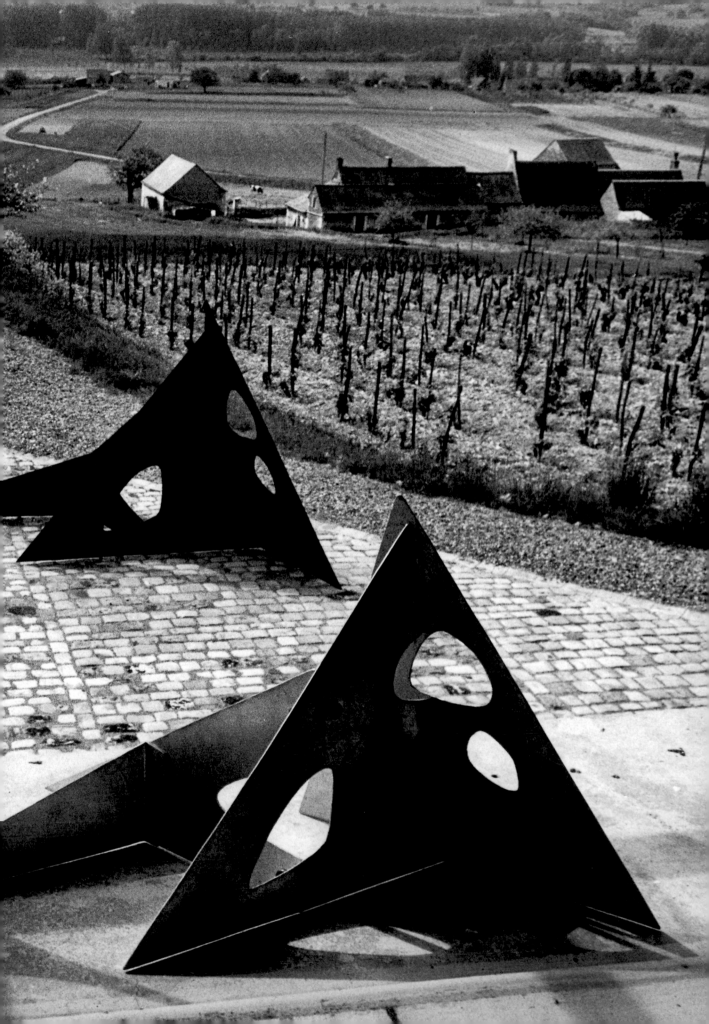

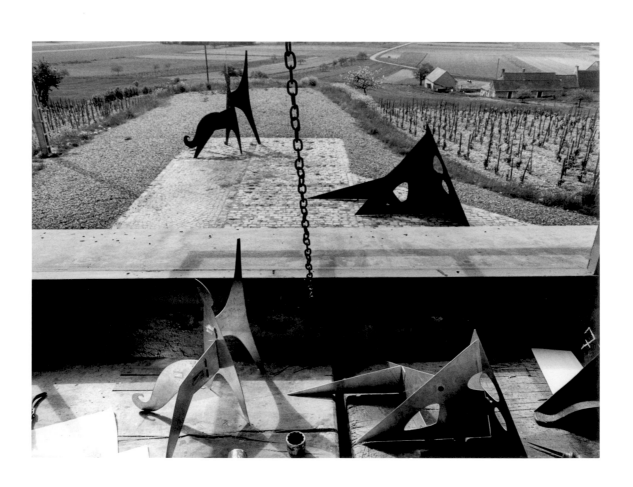

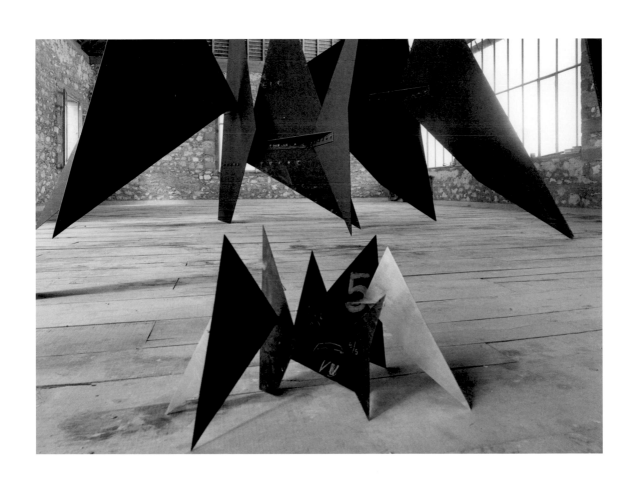

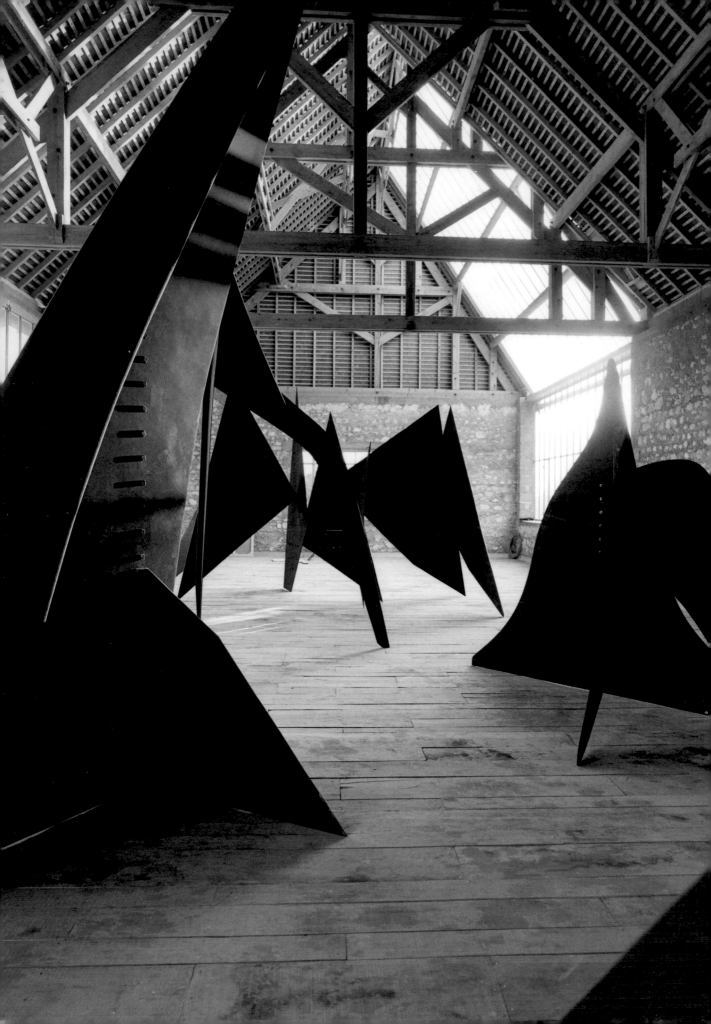

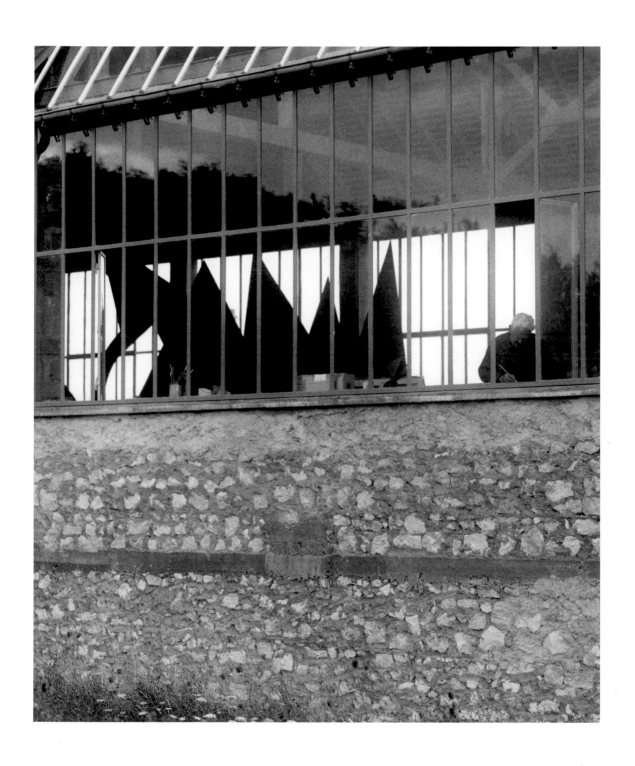

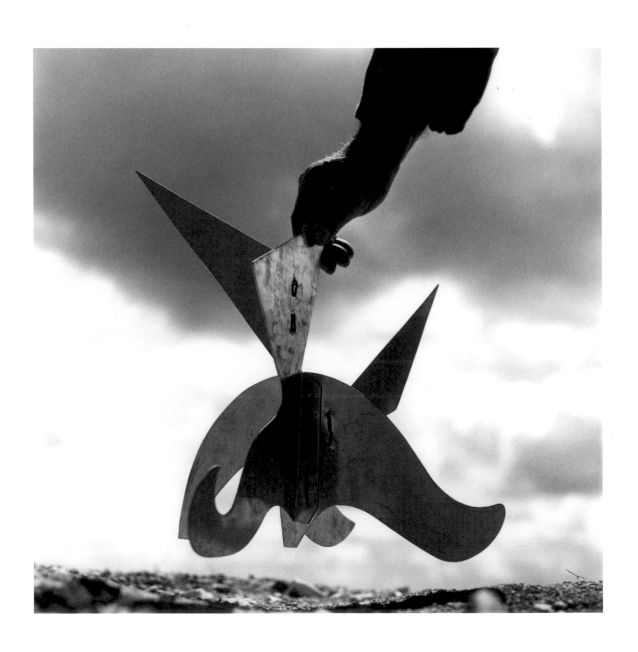